A YEAR OF
DAILY GRATITUDE

A YEAR OF
DAILY GRATITUDE

A Guided Journal for Creating
Thankfulness Every Day

Lorraine Miller

NATIONAL GEOGRAPHIC

WASHINGTON, D.C.

Published by National Geographic Partners, LLC
1145 17th Street NW Washington, DC 20036

ISBN: 978-1-4262-1715-9

Since 1888, the National Geographic Society has funded more than
12,000 research, exploration, and preservation projects around the
world. National Geographic Partners distributes a portion of the funds
it receives from your purchase to National Geographic Society to support
programs including the conservation of animals and their habitats.

National Geographic Partners
1145 17th Street NW
Washington, DC 20036-4688 USA

Become a member of National Geographic and activate
your benefits today at natgeo.com/jointoday.

For information about special discounts for bulk purchases,
please contact National Geographic Books Special Sales:
specialsales@natgeo.com

For rights or permissions inquiries, please contact National Geographic
Books Subsidiary Rights: bookrights@natgeo.com

Interior design: Katie Olsen

Printed in Hong Kong

16/THK/1

CONTENTS

INTRODUCTION

⌒

WHAT ARE YOU GRATEFUL FOR? Like most
people, you probably have no trouble answering
this question. After all, it is human nature to be
grateful.

The *real* question is, how often are you reaping the
rewards of all that your gratefulness can offer? How
often are you feeling joy rather than stress, love rather
than fear, and gratitude rather than deprivation?

We make choices every minute of every day. We can
choose to see life as wonderful and exciting, or
stressful and difficult. But choices like these are not
always easy to make. So much gets in the way of keeping
a positive mind-set. Daily stress, life events, and illness
can often squash our attempts at feeling happy. Life
becomes a struggle and we have trouble seeing what is
right in front of us, waiting to be enjoyed.

That is what this book is for. It is a tool to help you
practice gratitude as a means for discovering more
ease, more peace, more love, and more joy every single
day. The pages that follow are your opportunity to
delve deep into that place in your heart where gratitude

lives. Getting in touch with this part of you can be a journey of a lifetime, if you choose it to be.

Are you ready?

Let's go!

To ensure you get the most out of this book, here are some tips to help you thrive with gratitude:

1. **Do it with love.** Set the stage for making this book a powerful tool in your life by cherishing it with love and joy. Keep it somewhere visible where you'll be reminded to use it daily—your nightstand, an open shelf, or next to a favorite chair. Keep it away from other books and magazines that end up piling onto your to-do list. Designate a good pen to use when writing in your journal and keep it close by.

2. **Start where you are.** You'll notice that certain days throughout this book include helpful tips or activities to enhance your practice while other days offer inspiring quotations and thought-provoking photography. If you are new to practicing gratitude, it's important to write in this journal every day, especially for the first few months. Daily practice rewires your brain so that gratitude becomes habit forming. On the days without tips or activities, find three things you are grateful for and jot them down somewhere on the page. This should only take you a

few minutes. Always focus on the feeling you get when you think about the items on your list—this second step will make all the difference. If you miss a day or two, don't worry. Just pick up as soon as you can. You can always fill in missing days when you have the time.

If you already have experience with gratitude, treat this book as an important next step to developing your practice. Give yourself permission to devote time to the exercises that inspire you most. Be creative in how you choose to explore them. Not every tip or activity will resonate with you—that is okay. What's important is staying focused on what you are grateful for and making time for a little daily gratitude in a way that is enjoyable for you.

3. **Check your pulse.** Be on the lookout for any changes that come along as you travel this journey through gratitude. Some changes may happen in a matter of weeks, and others may take months. Be careful not to judge the process. Let things unfold in their own time. In early months, you may notice that you have more energy or that you feel more grounded, less moody, or less

stressed. You may find you are sleeping better, exercising more, and enjoying food more. In later months, you may find your relationships flourishing, your workdays easier, or your house looking cleaner. Pay attention to anything new that happens in your life and see if you can find a connection to your practice.

Monthly reflection helps in two ways: As you begin to notice the effects gratitude is having in your life, you are able to appreciate your practice as yet another gift to be grateful for and are motivated to keep going.

At the end of the year, you will have a blueprint for keeping happiness alive in your life. The items you choose to include on these pages—those things that answer the question "What are you grateful for?"—are things that *already* give you peace, love, and joy. The only difference will be in your having a greater awareness and appreciation for them.

There is no need to look any further than within your own heart to live the life you dream. Let gratitude lead the way.

• • •

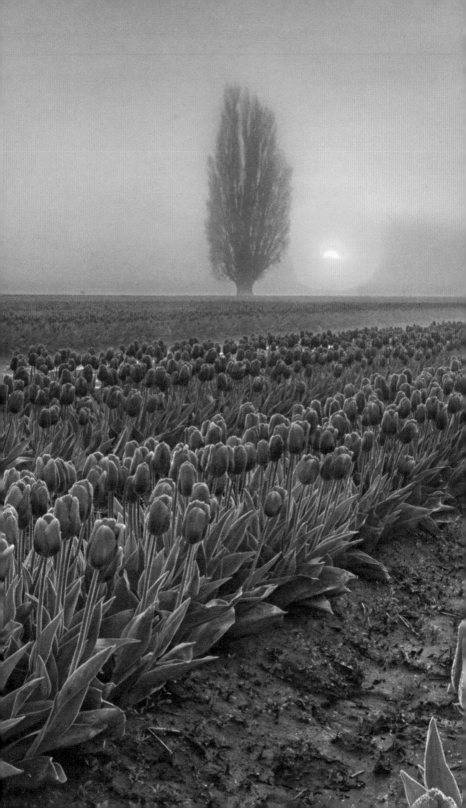

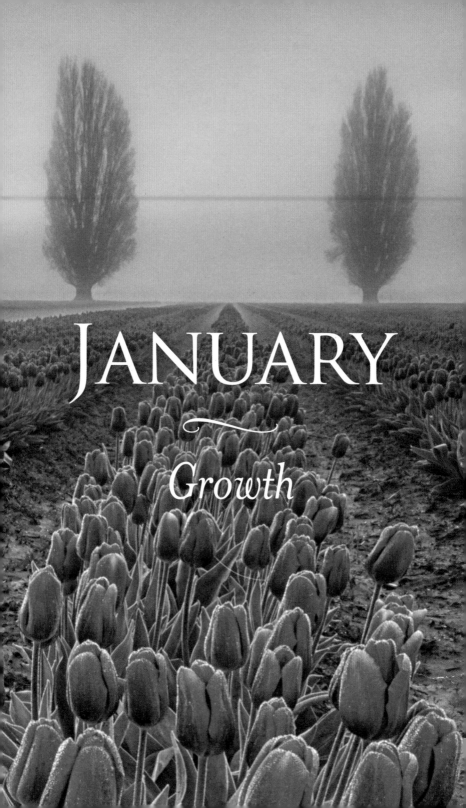

January

Growth

JANUARY 1

~⌇~

GROWTH TIP
Wake-Up Call

Begin this new year by creating a morning
gratitude routine. Spend five minutes jotting
down a few things you are thankful for—
a good night's rest, a kiss from your spouse,
spending time with your kids—and take
a moment to reflect on how these things
make you feel. Let this emotion nourish you
and keep you grounded in peace and joy.
Notice how this simple practice sets
a positive tone for the rest of your day.

• • •

Reflect here: ..

...

...

...

...

...

...

...

JANUARY 2–3

Life loves to be taken by the lapel and told:
"I'm with you kid. Let's go."

~ MAYA ANGELOU

JANUARY 4–5

Start where you are. Use what you have.
Do what you can.

~ ARTHUR ASHE

JANUARY 6

GROWTH TIP
Fake It Till You Make It

For some, being grateful comes easily
(scientists have even identified an associated gene).
However, if you find gratitude challenging,
don't give up trying. Each day, find a moment
to consciously practice appreciation—even for
something as simple as a glass of water.
That thought can stimulate the part of your
brain that creates feelings of joy and pleasure,
which ups your overall capacity for gratitude.
So next time you feel down, find something—
anything—to be grateful for and notice how
this shift in focus changes your mood.

• • •

Reflect here: ...

JANURARY 7

TRY THIS
Score a Goal

The new year is a time for putting dreams
in motion. Write down a few goals you'd like
to accomplish this year. Keep them simple
but clear. More important than the goal itself
is imagining how you will *feel* as a result of
achieving it. If your goal, for example, is to get
a promotion or raise at work, think about how
earning more may allow you to feel more
peaceful and free. If your goal is to lose weight,
picture yourself feeling lighter and more
energetic. Keep this feeling with you as
you strive to reach new heights this year.

• • •

Reflect here: *Lose weight.*
More confident and
feel good in
my clothes.
Have clothes
in my closet
that I love and
look really good in.
No more big clothes to
cover up my body.

~ 16 ~

January 8–9

If we don't believe the things we put
on our agendas will come true for us,
then there's no hope for us . . .
We've got to believe in our beautiful
impossible blueprints.

~ Doris Lessing, *The Golden Notebook*

JANUARY 10–11

The world of the future is in our making.
Tomorrow is now.

~ ELEANOR ROOSEVELT

JANUARY 12

～

GROWTH TIP
In a Heartbeat

Did you know that your heart rhythms
become irregular when you're stressed out?
Happily, studies show that simply thinking
of something you are grateful for reverses this
effect. So the next time you're feeling frazzled—
stuck in traffic, in an argument, or working
late—conjure up something or someone
that makes your life worthwhile. Breathe deep,
take in that gratitude, and push out the stress.

• • •

Reflect here: ..

..

..

..

..

..

..

..

..

..

JANUARY 13

THINK ABOUT ...
What Makes You Amazing

Today, focus on all the things you love
about you. How do you help others in
your life? What are the things you do better
than anyone else? How do you make other
people smile? Take time to look inward
and appreciate the little things that make
you unique. Celebrate you!

• • •

Reflect here: *My smile can light
up a room. I bake and
cook really good. I love
dogs like nobody else and
they love me. Easy
going. Funny. Hard
worker. Make other
people feel at ease.*

JANUARY 14–15

You are the one and only ever you.

~ NANCY TILLMAN,
ON THE NIGHT YOU WERE BORN

JANUARY 16–17

*To love what you do and feel it matters—
how could anything be more fun?*

~ KATHARINE GRAHAM

JANUARY 18

～

GROWTH TIP
Best Friends Forever

How you speak to yourself plays a critical role
in your own happiness. When you've experienced
a setback, choose to think in words that are
caring and encouraging rather than harsh
or critical. Remember all those things you
love about you? Bring them to the forefront
of your mind. Then, thank yourself for all
the good you did today—getting to the gym,
putting in extra hours at the office, starting
that book you've been meaning to read.
Being kind to yourself allows you to enjoy
life more and give more to others.

• • •

Reflect here: ..

..

..

..

..

..

..

..

JANUARY 19

TRY THIS
Have a Ball

What's one thing you really love to do,
something that excites you and fulfills you?
Schedule time each week—no excuses!—
to fit it into your schedule. Take an art class,
visit your favorite park, or go dancing.
Appreciate this occasion and know that
you deserve it. Remember that making time
for fun is just as important to your health
as eating right and getting exercise.

• • •

Reflect here: *Skiing. Going for
a walk. Shopping.
Going to a coffee shop.
Visiting and/or talking
to Linda and Lee and
Shelley and Jessie.*

JANUARY 20–21

*Tell me, what is it you plan to do with your
one wild and precious life?*

~ MARY OLIVER

JANUARY 22–23

Somewhere, something incredible
is waiting to be known.

~ CARL SAGAN

JANUARY 24

GROWTH TIP
Be Alert

Starting anything new can seem challenging
at first. Remember how you felt when you first
learned to drive a car or ride a bike? You had
to think about each individual action before
they flowed together. Gratitude practice works
the same way. To help, set a daily reminder
on your phone that says, "What are you grateful
for right now?" or post sticky notes around your
personal spaces, such as on your front door,
that read, "Grateful for home!"
Eventually, you won't need reminders.

• • •

Reflect here: ..
..
..
..
..
..
..
..

JANUARY 25–26

*To have that sense of one's intrinsic worth,
which constitutes self-respect,
is potentially to have everything.*

~ JOAN DIDION

JANUARY 27–28

Suddenly you find—at the age of fifty, say—
that a whole new life has opened before you . . .
as if a fresh sap of ideas and thoughts
was rising in you.

~ AGATHA CHRISTIE

JANUARY 29–30

*The privilege of a lifetime
is being who you are.*

~ JOSEPH CAMPBELL

JANUARY 31

TRY THIS
Finish Strong

How you end your day is just as important
as how you begin it. Try slowing down before
bedtime with a warm bath, soothing music,
or chamomile tea—whatever feels most relaxing
to you. Turn off your phone and dim the lights
or light a candle. Imagine the day's stress
melting away as you take several deep breaths.
Focus on one thing that went well today.
Breathe in the feeling of gratitude as you
close your eyes and fall asleep.

• • •

Reflect here: ..

..

..

...

...

...

..

..

...

...

FEBRUARY

Family

FEBRUARY 1

❧

FAMILY TIP
Family Matters

Most of us include "family" as a blanket item
on our gratitude lists. But when we focus
on the details about our family members,
instead of viewing them as a collective whole,
we appreciate them in a brand-new way.
Make a new list that identifies how each
person in your family brings you joy,
laughter, encouragement, and support.
"My sister for teaching me how to ski" and
"My uncle for helping me find my first job"
are some ideas to get you started.

• • •

Reflect here: ...

...

...

...

...

...

...

FEBRUARY 2–3

Family is not an important thing.
It's everything.

~ MICHAEL J. FOX

FEBRUARY 4–5

*Other things may change us, but we start
and end with the family.*

~ ANTHONY BRANDT

FEBRUARY 6

TRY THIS
Let the Little Things Shine

Next time a loved one offers you a small
kindness—bringing in your mail, folding your
laundry—try saying "Thank you" with more
intention than you normally do. Allow yourself
to fully appreciate the small gift and return it
by connecting to your loved one in gratitude.
Too many times we take for granted these little
acts of kindness and miss out on the joy
that comes from being thankful.

• • •

Reflect here: ...

..

..

..

..

..

..

..

..

February 7

FAMILY TIP
Role Model Behavior

The best way to teach a child to be grateful is
to serve as a model. This is true for adults too,
since gratitude is contagious. Think about how
often you are thankful compared to how often you
complain or gossip. Every day, shift the balance
toward gratitude in conversations you have
with family and friends. The more often you show
how grateful you are for the people in your life,
the more appreciated they will feel—and in turn
they will become more grateful for you,
and others. Help perpetuate the cycle of love!

• • •

Reflect here: ...

..

..

..

..

..

..

FEBRUARY 8–9

*Call it a clan, call it a network, call it a tribe,
call it a family. Whatever you call it,
whoever you are, you need one.*

~ JANE HOWARD

FEBRUARY 10–11

Remember, we all stumble, every one of us.
That's why it's a comfort to go hand in hand.

~ EMILY KIMBROUGH

February 12–13

The family is one of nature's masterpieces.

~ George Santayana

FEBRUARY 14

～

THINK ABOUT ...
Your Tribe

Who are the people in your life who know
you the best? Perhaps they are blood relations—
parents, siblings, children, aunts, uncles,
cousins, and grandparents. Or they may also
be a family you have made for yourself at work,
your place of worship, your neighborhood,
or among friends. Take some time today to
think of the other "families" in your life and
all the ways they bring you comfort and joy.

• • •

Reflect here: ...

...

...

...

...

...

...

...

FEBRUARY 15–16

*Families are ecosystems. Each life grows
in response to the lives around it.*

~ MARY SCHMICH

February 17–18

*God could not be everywhere,
and therefore he made mothers.*

~ Jewish proverb

February 19–20

Give a little love to a child, and you get a great deal back.

~ John Ruskin

Reflect here: ..

..

..

..

..

FEBRUARY 21

⌐∽⌐

TRY THIS
Family Gratitude Night

Have your own family join in on your path
toward gratitude. Throughout the week,
ask everyone to jot down what they are thankful
for in a family journal or on pieces of paper
you place in a jar. Choose a time—perhaps
Sunday dinner—for each person to read his
or her contribution aloud. Have fun reflecting
on all the good that happened that week.

• • •

Reflect here: ...

..

..

..

..

..

..

..

..

..

..

FEBRUARY 22–23

Every child begins the world again.

~ HENRY DAVID THOREAU

February 24–25

What can we make of the inexpressible joy
of children? It is a kind of gratitude.

~ Annie Dillard

FEBRUARY 26

～

THINK ABOUT ...
Raising Happy Kids

Research shows that grateful kids lead happier
lives, with higher GPAs, more friendships,
less envy, and less depression. Lead your
children toward gratitude by paying attention
to the subtle messages they send you. When
they seem worked up by friendship drama
or problems at school, help guide them back
to all of the positives in their life: that goal
they scored in soccer, the play date they have
coming up with a friend, that good grade
they got on a test. Focusing on gratitude
early in life will help them succeed.

• • •

Reflect here: ..
..
..
..
..
..
..
..

FEBRUARY 27

⌒

FAMILY TIP
Power Off

Spending time with family is key to maintaining
a strong bond. More important than the *amount*
of time you spend together is the *quality* of
that time. So for an hour each night, make
an effort to disconnect from your electronic
devices and truly "plug in" to those around you.
Give loved ones your full attention. Be curious
about their day and mindful of their needs.
Cherish your moments together.

• • •

Reflect here: ..
..
..
..
..
..
..
..
..

February 28–29

Always kiss your children goodnight—
even if they're already asleep.

~ H. Jackson Brown, Jr.

MARCH

⁓

Friendship

MARCH 1

~

FRIENDSHIP TIP
Make a Date

"Our relationships matter more than anything
else when it comes to human happiness,"
says sociologist Christine Carter, Ph.D.
Spending time with the people you love helps
you feel your best—so commit to connecting
with friends this month. Plan a visit over coffee
or make a phone date with those who live
far away. Be the one to reach out and make
it happen. You'll be glad you did.

• • •

Reflect here: ...

..

..

..

..

..

..

..

..

MARCH 2–3

*The process of falling in love at first sight is
as final as it is swift in such a case, but the growth
of true friendship may be a lifelong affair.*

~ SARAH ORNE JEWETT, *THE COUNTRY
OF THE POINTED FIRS*

MARCH 4–5

When I count my blessings,
I count you twice.

~ IRISH PROVERB

MARCH 6–7

*It's the friends you can call up
at 4 a.m. that matter.*

~ MARLENE DIETRICH

Reflect here: ...
..
..
..
..

MARCH 8

TRY THIS
Be Positively Contagious

Who are the friends who matter most
in your life? Take a moment to reflect on
the different ways your friends make you feel.
Ask yourself, "Does this person boost my mood
or drag me down?" Weed out those who infuse
your life with negativity and turn to those
who bring you joy. Consider these traits
when meeting new people.

• • •

Reflect here: ...

..

..

..

..

..

..

..

..

MARCH 9–10

Some people need a red carpet rolled out in front of them in order to walk forward into friendship. They can't see the tiny outstretched hands all around them, everywhere, like leaves on trees.

~ MIRANDA JULY

MARCH 11–12

*Laughter is the shortest distance
between two people.*

~ VICTOR BORGE

MARCH 13–14

*We learned how to create beauty
where none exists, how to be generous
beyond our means, how to change
a small corner of the world just by making
a little dinner for a few friends.*

~ GABRIELLE HAMILTON

Reflect here: ...

...

...

...

...

MARCH 15

FRIENDSHIP TIP
Live Longer, Together

Friendships don't just affect our happiness;
they influence our health too. According to
Dan Buettner, author of *The Blue Zones Solution,*
choosing healthy friends is "perhaps the most
significant thing you can do to add more years
to your life and more life to your years."
Who you spend time with, how active *they* are,
and what *they* eat can influence *your* health.
Seek out healthy people and notice
the ways they affect your life.

• • •

Reflect here: ...

..

..

..

..

..

..

..

..

March 16–17

We secure our friends not by
accepting favors but by doing them.

~ Thucydides

March 18–19

Ah, how good it feels!
The hand of an old friend.

~ Henry Wadsworth Longfellow

MARCH 20

THINK ABOUT ...
Your Friend Factor

Never underestimate your own worth
in a friendship. Just being there for someone
in a time of need can be the greatest gift you
ever give—and the foundation for a deep
and lasting friendship. Reflect on some
of the ways you've been a good friend.
Are you the first to respond in a crisis?
Always the one to make someone laugh?
A good, nonjudgmental listener? Write these
traits down and appreciate yourself for them.

• • •

Reflect here: ...
..
..
..
..
..
..
..

MARCH 21–22

*"Why did you do all this for me?" he asked.
"I don't deserve it. I've never done anything
for you." "You have been my friend,"
replied Charlotte. "That in itself
is a tremendous thing."*

~ E. B. WHITE, *CHARLOTTE'S WEB*

Reflect here: ...
...
...
...
...

March 23–24

There's not a word yet for old friends
who've just met.

~ Jim Henson

MARCH 25–26

My friends have made the story of my life.

~ HELEN KELLER

MARCH 27

TRY THIS
Make Friendships Matter

How can you make friendship, not work
or chores, a priority in your life? Set aside
regular times each week to spend with friends—
a Monday movie night or Friday morning
walk—and make sure nothing gets in the way.
This special time will make your life richer
and more satisfying, and will provide much
needed stress relief from the everyday grind.

• • •

Reflect here: ...

...

...

...

...

...

...

...

...

...

March 28–29

*Sometimes our light goes out but is blown
into flame by another human being.
Each of us owes deepest thanks to those
who have rekindled this light.*

~ Albert Schweitzer

Reflect here: ...

..

..

..

..

MARCH 30–31

We are all travelers in the wilderness
of this world, and the best we can find
in our travels is an honest friend.

~ ROBERT LOUIS STEVENSON

APRIL

Love

APRIL 1

⁓

LOVE TIP
A Heart of Gold

Feeling grateful every day opens your heart
to giving and receiving love. Close your eyes
and focus your attention on your heart.
Think of something or someone you are
truly grateful for. Imagine your heart expanding
as you fill it with love. Allow yourself to fully
receive this gift. Take a deep breath and
open your eyes. Repeat this exercise any time
you need a dose of happiness in your day.

• • •

Reflect here: ..

..

..

..

..

..

..

..

..

April 2–3

Gratitude is a short cut which
speedily leads to love.

~ Théophile Gautier

APRIL 4–5

I have learned not to worry about love;
but to honor its coming with all my heart.

~ ALICE WALKER

APRIL 6–7

Love is the true means by which the world is enjoyed: our love to others and others' love to us.

~ THOMAS TRAHERNE

APRIL 8

THINK ABOUT ...
The Power of Love

Taking care of others can often feel like
a thankless job. Having to nag your child
to clean her room or your husband to mow
the lawn isn't fun. But in reality, what you're
really doing is empowering your child to be
responsible and letting your husband know how
much you need his help. Stay focused on *why*
you're asking so you can approach the task
at hand from a place of love rather
than annoyance. Using the power of love
in your daily communications will bring joy
and gratitude to your relationships.

• • •

Reflect here: ..

..

..

..

..

..

..

APRIL 9–10

*The things that we love
tell us what we are.*

~ St. Thomas Aquinas

April 11–12

I love her and that's the beginning
and end of everything.

~ F. Scott Fitzgerald

APRIL 13–14

Lovers don't finally meet somewhere.
They're in each other all along.

~ RUMI

Reflect here: ...
...
...
...
...
...
...

APRIL 15

⌒

TRY THIS
Renew Your Love

Make a list of things you love about someone
special in your life. Include the little ways they
make you smile—a kiss hello, a ride to work,
keeping date night—as well as the bigger ones:
supporting your greatest dreams, sharing in
raising your children, standing by you on
the toughest days. We often forget how much
others do for us as life gets busy. Taking time
to remember *why* you love someone helps
your love grow stronger.

• • •

Reflect here: ...
..
..
..
..
..
..
..
..

APRIL 16–17

*He felt now that he was not simply
close to her, but that he did not know
where he ended and she began.*

~ LEO TOLSTOY

APRIL 18–19

Love is everything it's cracked up to be . . .
It really is worth fighting for, being brave for,
risking everything for. And the trouble is, if you
don't risk anything, you risk even more.

~ ERICA JONG

APRIL 20

~

LOVE TIP
Spice Things Up

Saying "Thank you" could be the easy secret to
a happy marriage. Researchers at the University
of Georgia found that feeling appreciated in
a relationship directly influences how committed
you are to making it last. So instead of getting
angry about the mess your spouse left in the
kitchen, try thanking them for making dinner
instead. It could make all the difference.

• • •

Reflect here: ..

..

..

..

..

..

..

..

..

..

April 21–22

Gratitude is a twofold love—love coming to visit us
and love running out to greet a welcome guest.

~ Henry van Dyke

April 23–24

We can only learn to love by loving.

~ Iris Murdoch

APRIL 25–26

Where there is great love,
there are always miracles.

~ WILLA CATHER

APRIL 27

~

LOVE TIP
Love Yourself

Loving yourself is more important
to your health than any other lifestyle choice.
Start each day by thanking yourself for one
thing: your hard work, your positive attitude,
even the way you smile. Use that positivity as
motivation to eat healthier foods, get regular
sleep, exercise, and spend time with people
you love. Appreciating yourself is a natural
way to feel both healthy and happy.

• • •

Reflect here: ..

..

..

..

..

..

..

..

..

..

APRIL 28

THINK ABOUT ...
Loving Unconditionally

When you're truly grateful for someone special
in your life, you can love them unconditionally
by becoming more tolerant of their faults
and more forgiving of their mistakes. The next
time this person upsets you, take a deep breath
and focus on what makes you love them
before considering their faults. Redirecting
your negative emotions will allow you to address
your concerns from a place of love, not anger.

• • •

Reflect here: ...

...

...

...

...

...

...

...

...

APRIL 29–30

It's no trick loving somebody at their best.
Love is loving them at their worst.

~ TOM STOPPARD, *THE REAL THING*

MAY

Happiness

MAY 1

HAPPINESS TIP
First Things First

Studies show that keeping a daily gratitude
journal increases happiness levels by 25 percent.
Almost halfway through the year, make sure
your gratitude journal is a priority. If you
find you are forgetful, set a daily reminder on
your phone and keep your journal in full sight.
Or, make journaling time extra special
with a favorite cup of tea and a song playing
as you write. No one can increase
your happiness for you.

• • •

Reflect here: ...

...

...

...

...

...

...

...

May 2–3

We can only be said to be alive in those moments
when our hearts are conscious of our treasures.

~ THORNTON WILDER

MAY 4–5

*Happiness is anyone and anything at all
that's loved by you.*

~ CLARK GESNER

MAY 6–7

It isn't the big pleasures that count the most;
it's making a great deal out of the little ones.

~ JEAN WEBSTER

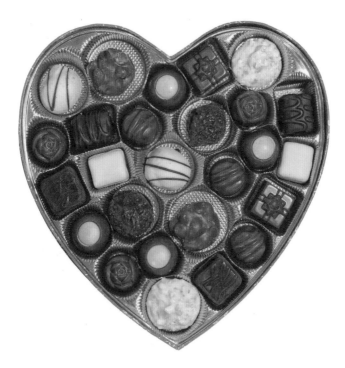

MAY 8

TRY THIS
One on One

Write a thank-you letter to someone who
has made a difference in your life—a parent,
grandparent, teacher, or friend. Include
specifics of how they have been a blessing
to you. But instead of mailing your note,
visit this person and read your letter aloud.
Gratitude visits like this have been
scientifically proven to increase happiness
for both the giver and the receiver.

• • •

Reflect here: ..

..

..

..

..

..

..

..

..

..

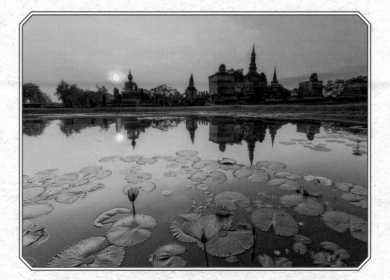

MAY 9–10

Life is precious as it is. All the elements
for your happiness are already here.
There is no need to run, strive,
search, or struggle. Just be.

~ THICH NHAT HANH

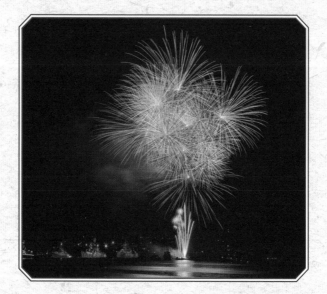

MAY 11–12

❦

*Love the moment, and the energy of that moment
will spread beyond all boundaries.*

~ SISTER CORITA KENT

MAY 13

⌒

THINK ABOUT ...
Taking Care of You

Getting a good night's sleep, participating in
an exercise routine you enjoy, taking time out
to relax, and being with people you love all have
tremendous impact on your mood and energy
level. When any of these things fall out of
balance, it can detract from your overall
happiness. If you're feeling out of whack,
think about the things you can do today
to get back on track. Is it taking a lunch break
at work to catch up with a friend? Trying a new
class at the gym? Take the time to rejigger
your schedule until you feel steady again.

• • •

Reflect here: ...

...

...

...

...

...

...

...

MAY 14–15

Let us be grateful to the people who make us happy; they are the charming gardeners who make our souls blossom.

~ MARCEL PROUST

Reflect here: ...

..

..

..

..

..

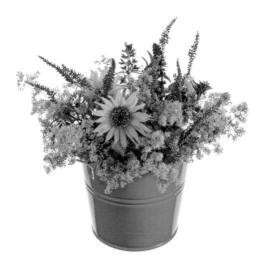

MAY 16–17

Nothing is worth more than this day.

~ JOHANN WOLFGANG VON GOETHE

May 18–19

The soul is here for its own joy.

~ Rumi

MAY 20–21

Yesterday is but a dream, tomorrow but a vision.
But today well lived makes every yesterday
a dream of happiness, and every tomorrow
a vision of hope. Look well, therefore, to this day.

~ SANSKRIT PROVERB

Reflect here: ..

...

...

...

...

MAY 22–23

When spring came, even the false spring,
there were no problems except
where to be happiest.

~ ERNEST HEMINGWAY

Reflect here: ...

..

..

..

..

..

May 24–25

*The best way to pay for a lovely moment
is to enjoy it.*

~ Richard Bach

MAY 26–27

Happiness is like a butterfly which,
when pursued, is always beyond our grasp,
but, if you will sit down quietly,
may alight upon you.

~ NATHANIEL HAWTHORNE

MAY 28

HAPPINESS TIP
Satisfy Your Cravings

Studies show that focusing on what you
are grateful for activates the frontal region
of the brain and increases production of
dopamine, a mood-enhancing neurotransmitter
that also plays a role in food cravings. When we
eat sugar, for example, dopamine makes us feel
pleasure and want more. The next time you find
yourself reaching for that doughnut, take a
breath and focus on something you're grateful
for instead. Fill your plate with love instead
of sweets. Second helpings are allowed.

• • •

Reflect here: ...

...

...

...

...

...

...

MAY 29

⌒

TRY THIS
Happiness on Tap

Close your eyes. Imagine you are sitting in
your favorite place—a sandy beach, your parents'
kitchen, the woods. Notice the sounds you hear,
the scents you smell, and the temperature of
the air. Sit quietly for a few minutes and breathe
in the peacefulness of this place. Allow the
energy you feel to fill you up from head to toe.
When you are ready, take a deep, cleansing
breath and open your eyes. Do this whenever
you feel overwhelmed or exhausted—
it's a great way to revive your mood.

• • •

Reflect here: ...

...

...

...

...

...

...

...

MAY 30–31

Follow your bliss.

~ JOSEPH CAMPBELL

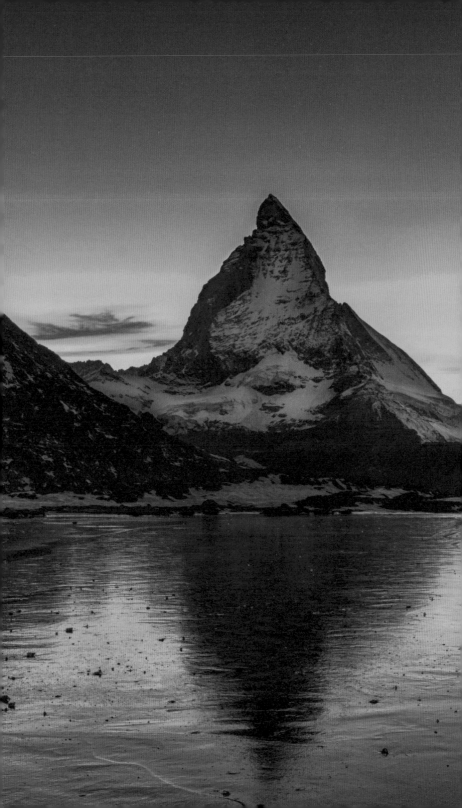

JUNE

Beauty

JUNE 1

BEAUTY TIP
From Ear to Ear

According to a study conducted at the University
of Aberdeen, Scotland, men and women were
more attracted to images of people who made
eye contact and smiled than those who did not.
Take time to slow down and greet everyone you
see today with a warm, friendly smile—and be
sure to look him or her in the eye too.
Be grateful for the connections you make.

• • •

Reflect here: ...

...

...

...

...

...

...

...

...

JUNE 2–3

May my heart always be open to little birds
who are the secrets of living.

~ E. E. CUMMINGS

June 4–5

One cannot collect all the beautiful shells on the beach. One can collect only a few, and they are more beautiful if they are few.

~ Anne Morrow Lindbergh

JUNE 6–7

*What a morning—fresh as if issued
to children on a beach.*

~ Virginia Woolf

Reflect here: ...

...

...

...

...

...

...

JUNE 8

THINK ABOUT ...
Turning Inside Out

Think about the physical characteristics
of someone you love: the color of their eyes,
the sound of their laugh, the shape of their
hands. Now think about their inner qualities:
their kindness, generosity, sense of humor,
trustworthiness. Which are most important
to you? How do their best qualities outweigh
their imperfections? Taking time to examine
this person's inner and outer strengths
will broaden your appreciation and allow
you to see them in all their beauty.

• • •

Reflect here: ..

..

..

..

..

..

..

..

JUNE 9–10

Everything has its beauty,
but not everyone sees it.

~ CONFUCIUS

JUNE 11–12

*Above all, watch with glittering eyes
the whole world around you because
the greatest secrets are always hidden in
the most unlikely places. Those who don't
believe in magic will never find it.*

~ ROALD DAHL, *THE MINPINS*

JUNE 13

TRY THIS
Take a Hike

Studies show that being outdoors increases
vitality. A gratitude walk is a great way
to boost your energy when you're feeling
tired or stressed. Choose a place with
plenty of natural beauty—a beach, woods,
or city park—and get walking! Notice the
colors and sounds around you. Breathe in
the fresh air. As you walk, silently give
thanks for these life-enhancing gifts.

• • •

Reflect here: ...

...

...

...

...

...

...

...

...

~ 121 ~

JUNE 14–15

Going to the woods is going home.

~ JOHN MUIR

Reflect here: ..

..

..

..

..

..

..

JUNE 16–17

*Nature seems to have implanted gratitude
in all living creatures.*

~ SAMUEL JOHNSON

June 18–19

Even after all this time, the sun never says
to the earth, "You owe me." Look what happens
with love like that. It lights the whole sky.

~ Hafiz

JUNE 20

BEAUTY TIP
Get Your Beauty Rest

The next time you work late or have a hectic
travel schedule, try writing in your gratitude
journal just before bed. A study conducted
by the University of Manchester, England,
showed that gratitude participants fell asleep
faster, slept better and longer, and were more
functional during the day than those who did
not. If you've already written in your journal
that morning, review your list before dozing off.
You'll have sweeter dreams, be better able to
handle stress, and be more aware of
the beauty that surrounds you.

• • •

Reflect here: ...

..

..

..

..

..

..

..

JUNE 21

⌒

BEAUTY TIP
Take It In

Retreat from the everyday rush by picking
one day a week to intentionally slow down.
Wake up a little earlier so you can enjoy a walk
through the park on your way to work or take
the scenic route after dropping off the kids.
Spend time on your commute noticing
the things about your neighborhood that
you find beautiful. By taking a closer look
at your surroundings, you'll enjoy a deeper
appreciation for where you live and a great
sense of connection to your local community.

• • •

Reflect here: ...
...
...
...

...
...
...
...
...

JUNE 22–23

Let the rain sing you a lullaby.

~ LANGSTON HUGHES

June 24–25

At some point in life the world's beauty becomes enough. You don't need to photograph, paint, or even remember it. It is enough.

~ Toni Morrison, *Tar Baby*

JUNE 26

~

THINK ABOUT ...
The Bright Side

Life isn't always easy, but take a step back
and you will often find the hardest challenges
you have faced are actually gifts. Think about
the tough experiences you've endured. What are
some of the most important lessons you learned
from the more difficult times in your life?
Did it bring new people into your world?
Did it help you grow? Consider these moments
as foundational steps in your life's journey.

• • •

Reflect here: ...

...

...

...

...

...

...

...

JUNE 27–28

*Nobody sees a flower, really—it is so small—
we haven't time, and to see takes time,
like to have a friend takes time.*

~ GEORGIA O'KEEFFE

JUNE 29–30

The earth is warmer when you laugh.

~ SAMUEL BEAM

JULY

Adventure

JULY 1

TRY THIS
Drop Your Plans

Take a spontaneous adventure. Grab a friend
and go for a drive to the mountains. Hop a train
to a city you've never visited. Try a new food at
an exotic restaurant. Whatever you do, your only
goal is to have fun. Breaking out of your daily
routine to experience new things every now
and then is energizing, inspiring, and incredibly
freeing—the perfect way to appreciate life!

• • •

Reflect here: ...

...

...

...

...

...

...

...

...

...

...

...

July 2–3

When shall we live if not now?

~ M. F. K. Fisher

July 4–5

*The biggest adventure you can ever take
is to live the life of your dreams.*

~ OPRAH WINFREY

JULY 6–7

Life itself is the proper binge.

~ JULIA CHILD

Reflect here: ...
..
..
..
..
..
..

July 8

ADVENTURE TIP
Be a Goaltender

Is there something you've always wanted
to do but can never seem to make happen?
Instead of thinking of all the reasons you can't
own that boat, start that business, or travel
around the world, focus on ways you can move
toward those goals. Make a list of resources you
already have and talk it through with a friend.
Staying positive will help you block negative
thoughts that are squashing your dreams.

• • •

Reflect here: ..
..
..
..
..
..
..
..

JULY 9–10

~⌒~

No, no! The adventures first.
Explanations take such a dreadful time.

~ LEWIS CARROLL, *ALICE'S ADVENTURES IN WONDERLAND*

JULY 11–12

*We all live in suspense, from day to day,
from hour to hour; in other words,
we are the hero of our own story.*

~ MARY MCCARTHY

July 13–14

Adventure is worthwhile in itself.

~ Amelia Earhart

Reflect here: ..

...

...

...

...

...

...

JULY 15

⁓

THINK ABOUT ...
Time Travel

Pick an experience in your life that made
you feel incredibly alive—your first love,
a trip overseas, becoming a mom.
Think back to that time and relive the
excitement you felt, but most importantly,
consider what came out of the experience.
What about this special time can you
appreciate today?

• • •

Reflect here: ..

..

..

..

..

..

..

..

..

JULY 16–17

Not all those who wander are lost.

~ J. R. R. TOLKIEN, *THE FELLOWSHIP OF THE RING*

JULY 18–19

It was the first peach I had ever tasted.
I could hardly believe how delicious.
At twenty-five I was dumbfounded afresh
by my ignorance of the simplest things.

~ TED HUGHES

July 20–21

There is a time for departure even when there's no certain place to go.

~ Tennessee Williams

JULY 22

⌒

ADVENTURE TIP
Find Your Own Fun

Turn everyday chores into fun excursions.
Need to run an errand? Make it more exciting
by keeping those yoga pants in the closet
and dressing up for a change (you never
know who you'll run into!). Laundry to fold?
Blast some opera music and pretend you're
in Tuscany. Life is full of adventures,
big and small. Sometimes it's the little ones
you create that are the most fun.

• • •

Reflect here: ...
...
...
...
...
...
...
...
...

JULY 23–24

A journey is a person in itself;
no two are alike.

~ JOHN STEINBECK

July 25–26

We love because it is the only true adventure.

~ Nikki Giovanni

JULY 27–28

All life is an experiment.
The more experiments you make
the better.

~ RALPH WALDO EMERSON

Reflect here: ...

...

...

...

...

...

JULY 29

⁓

ADVENTURE TIP
Go Out on a Limb

Being able to treat every new experience as
an adventure takes practice—but the reward is
a renewed sense of freedom and a greater ability
to live in the moment. Think of ways you can
step out of your comfort zone and create these
experiences more often. If you're introverted,
try striking up a conversation with a stranger.
If you've always wanted to play an instrument
or learn a new language, sign up for lessons *now*.
Be bold. Appreciate yourself for making a change.

• • •

Reflect here: ..

...

...

...

...

...

...

...

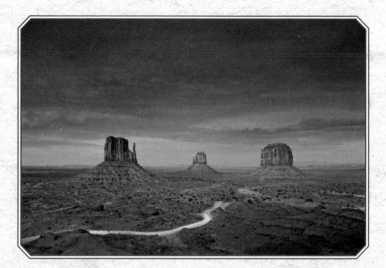

JULY 30–31

*Only those who will risk going too far
can possibly find out how far one can go.*

~ T. S. ELIOT

AUGUST

Home

AUGUST 1

⌒

HOME TIP
Home Is Where the Heart Is

As you continue to create your daily gratitude
list, begin to include things in your home
that bring you joy—your favorite pillow,
the view outside your kitchen window,
a painting on the wall. When things around
the house seem in disarray, find ways to stay
grateful for it all. Remember, dirty dishes
mean you had a good family meal,
mud on the carpet means your kids
enjoyed a day outside. Say hello to all
the blessings you have at home.

• • •

Reflect here: ..

..

..

..

..

..

..

..

August 2–3

No one realizes how beautiful it is to travel
until he comes home and rests his head
on his old, familiar pillow.

~ Lin Yutang

AUGUST 4–5

The power of finding beauty in the humblest things makes home happy and life lovely.

~ LOUISA MAY ALCOTT,
JACK AND JILL: A VILLAGE STORY

August 6–7

*The ordinary acts we practice every day at home
are of more importance to the soul than
their simplicity might suggest.*

~ Thomas Moore

Reflect here: ...

...

...

...

...

...

...

...

AUGUST 8

THINK ABOUT ...
Your Four Walls

Which rooms in your house do you
enjoy the most? The kitchen, where your
family comes together for dinner; your child's
playroom, where you read stories at night;
or the den, where you snuggle up on the couch
with a good book? Go through each room
and describe what makes your house a home—
the conversations, the activities, the warmth
you feel. Having a greater appreciation for
your home leads to greater peace in your life.

• • •

Reflect here: ...
...
...
...
...
...
...
...

AUGUST 9–10

We shape our dwellings, and afterwards our dwellings shape us.

~ WINSTON CHURCHILL

AUGUST 11–12

Love begins at home.

~ MOTHER TERESA

August 13–14

You can go other places, all right—
you can live on the other side of the world,
but you can't ever leave home.

~ SUE MONK KIDD, *THE MERMAID CHAIR*

Reflect here: ..

..

..

..

..

..

AUGUST 15

TRY THIS
Clean Up

Take note of how your physical space affects
your mood. If you're spending too much time,
and stress, hunting down that screwdriver
or pair of shoes you love, it's time to declutter.
Tackle cleaning out one drawer or shelf at
a time. Ask a friend or professional for help.
Decluttering your home can empower you to
make positive shifts in other areas of your life.

• • •

Reflect here: ..

..

..

..

..

..

..

..

..

AUGUST 16–17

Peace—that was the other name for home.

~ KATHLEEN NORRIS

August 18–19

The ache for home lives in all of us.
The safe place where we can go as we are
and not be questioned.

~ Maya Angelou

AUGUST 20–21

*Where we love is home—home that our feet
may leave, but not our hearts.*

~ OLIVER WENDELL HOLMES, SR.

Reflect here: ..

AUGUST 22

THINK ABOUT …
Making a House a Home

The *feeling* of home, even if you've left the house you grew up in years ago, stays with you forever. Which family traditions from your childhood do you remember most—raking leaves with Dad, helping Mom make banana bread, eating pancakes for dinner? Make sure you've brought those moments into your adult home. Then, think about the new traditions your own family has added to the mix. How do you celebrate every day? Appreciating these experiences instills a feeling of home that will stay with you and your family forever.

• • •

Reflect here: ...

...

...

...

...

...

...

August 23–24

Home is not where you live
but where they understand you.

~ Christian Morgenstern

AUGUST 25–26

Home is a place you grow up wanting to leave,
and grow old wanting to get back to.

~ JOHN ED PEARCE

AUGUST 27–28

*Wherever you are is my home—
my only home.*

~ CHARLOTTE BRONTË, *JANE EYRE*

Reflect here: ..

..

..

..

..

..

AUGUST 29

⌒

HOME TIP
Build Your Dream Home

Now that you've decluttered your space,
it's time to decorate it with things you love.
Your home is a reflection of you, so devote
a little time and thought to what inspires you
in order to create a peaceful, healthy atmosphere
you enjoy. Think about incorporating green
plants, photos of your family, artwork
that inspires you—simple things that will
put a smile on your face when you wake up
in the morning and come home at night.

• • •

Reflect here: ...

...

...

...

...

...

...

...

AUGUST 30–31

Be grateful for the home you have,
knowing that at this moment,
all you have is all you need.

~ SARAH BAN BREATHNACH

SEPTEMBER

Faith

September 1

FAITH TIP
Stay Focused

Maintaining your gratitude level keeps you strong
during difficult times. Get good at noticing
when you fall off the wagon. As soon as you start
to feel grumpy, snap at your kids, or complain
about the weather, take note. Get back on track
by reserving five minutes a day to focus
on gratitude. Consistency is key, and just
a few minutes creates results.

• • •

Reflect here: ..

..

..

..

..

..

..

..

..

..

September 2–3

*Faith is the centerpiece of a connected life.
It allows us to live by the grace
of invisible strands.*

~ Terry Tempest Williams

September 4–5

Above all, don't fear difficult moments.
The best comes from them.

~ Rita Levi-Montalcini

SEPTEMBER 6–7

The best way out is always through.

~ ROBERT FROST

Reflect here: ..

...

...

...

...

...

...

...

SEPTEMBER 8

THINK ABOUT ...
Finding Your Passion

Have you ever been so engrossed in
an activity that time seemed to fly by?
Gardening, dance class, reading a good book:
all have the potential to get you out of your
head and into your heart. Pick an activity
that you feel completely connected to and
make sure it gets a priority spot on your
calendar. Doing what you love—even once
a week—is critical to your well-being and can
be incredibly healing during difficult times.
It's always worth it to make time for you.

• • •

Reflect here: ..

..

..

..

..

..

..

SEPTEMBER 9–10

To have faith is to have wings.

~ J. M. BARRIE

SEPTEMBER 11–12

*To believe in something not yet proved
and to underwrite it with our lives; it is
the only way we can leave the future open.*

~ LILLIAN SMITH

September 13–14

When we lose one blessing, another is often most unexpectedly given in its place.

~ C. S. Lewis

Reflect here: ...

...

...

...

...

...

...

SEPTEMBER 15

FAITH TIP
Find Opportunity in Everything

Every experience has a silver lining. Instead of dwelling on a stressful situation, think of immediate ways you can grow from it. If you are struggling to pay the bills, find creative ways to budget that make your life easier for months to come. If your child is doing poorly in school, find him an amazing tutor that will help make learning more enjoyable. While challenging, proactively focusing on the positive helps you see that things can—and will—work out.

• • •

Reflect here: ..
..
..
..
..
..
..

SEPTEMBER 16–17

*Faith is not just something you have,
it's something you do.*

~ BARACK OBAMA

SEPTEMBER 18–19

*The only courage that matters is the kind
that gets you from one moment to the next.*

~ MIGNON MCLAUGHLIN

SEPTEMBER 20

TRY THIS
Heart Warmer

Let's face it: Life isn't always easy. When things
get complicated, we often look outside
for answers—but oftentimes, looking inward
is the better solution. How? Close your eyes
and try to quiet your mind. Focus your attention
on your heart. Imagine a gold sun in its center.
Feel its warmth. Trust in its power to help you
solve every problem by bringing you peace
and clarity. Breathe deeply and open
your eyes. Repeat as needed.

• • •

Reflect here: ...

...

...

...

...

...

...

...

SEPTEMBER 21

FAITH TIP
Dive Right In

Having faith that things will work out in
the end gives you the courage to step out
of your comfort zone and go for what you want.
Choose something you've been wanting to do—
ask for a promotion, move to a new city, buy a
new car—but haven't yet tackled. Close your eyes
and imagine how grateful you will feel after
you've taken the leap. Envision everything
working out. Practice this exercise every day
until you are ready to make it happen.

• • •

Reflect here: ...
...
...
...
...
...
...
...

September 22–23

Without faith, nothing is possible.
With it, nothing is impossible.

~ Mary McLeod Bethune

September 24–25

*Be like the bird that, pausing on her flight
awhile on boughs too slight, feels them
give way beneath her, and yet sings,
knowing that she hath wings.*

~ Victor Hugo

September 26–27

All you have to do is look straight
and see the road, and when you see it,
don't sit looking at it—walk.

~ AYN RAND, *WE THE LIVING*

Reflect here: ...

...

...

...

...

...

SEPTEMBER 28

~

THINK ABOUT ...
The Extraordinary in the Ordinary

In the aftermath of tragedy, people often
feel an overwhelming gratitude for life.
Don't wait for tragedy to strike. Today, think
of everything—brushing your teeth, using your
computer, driving your car—as if it was a gift.
Think of the joy you get from a job well done
at work, a beautiful morning jog, celebrations
with friends. Make a list of everything
you'd be most grateful for if you were
to leave the Earth tomorrow.

• • •

Reflect here: ...

..

..

..

..

..

..

..

September 29–30

*We are made to persist. That's how
we find out who we are.*

~ Tobias Wolff

OCTOBER

Perspective

OCTOBER 1

PERSPECTIVE TIP
Word Games

Words have the power to change your life.
From now on, whenever you hear yourself say,
"I *have* to meet a deadline, mow the lawn,
or run errands," flip the switch and say instead,
"I'm *lucky* to have a job I enjoy, a house with
a yard for my kids, and to be able to afford
the things I need." Consciously adjusting
your attitude about the mundane tasks in life
will lift your mood, boost your energy,
and improve your outlook on life.

• • •

Reflect here: ..

..

..

..

..

..

..

..

October 2–3

Everything we hear is an opinion, not a fact.
Everything we see is a perspective, not the truth.

~ MARCUS AURELIUS

OCTOBER 4–5

A little perspective, like a little humor,
goes a long way.

~ ALLEN KLEIN

OCTOBER 6–7

*If you look the right way, you can see
that the whole world is a garden.*

~ **FRANCES HODGSON BURNETT,**
THE SECRET GARDEN

Reflect here: ...

...

...

...

...

OCTOBER 8

⌒

TRY THIS
Find the Source

Pay attention to your thoughts today. Are they
hopeful or discouraging? Negative thoughts
often come from someone else—a worried
parent, a judgmental teacher, a stressed-out
boss—and can limit your potential for
happiness. Each time you hear yourself saying,
"I can't," hit the pause button and choose
a more positive, loving voice. Be patient.
In time you will be on positive autopilot.

• • •

Reflect here: ..

..

..

..

..

..

..

..

..

October 9–10

Since we cannot change reality,
let us change the eyes which see reality.

~ NIKOS KAZANTZAKIS, *REPORT TO GRECO*

OCTOBER 11–12

It is always the simple that produces the marvelous.

~ Amelia Barr

OCTOBER 13–14

Life is beautiful.

~ LEON TROTSKY

Reflect here: ..
...
...
...
...
...
...

OCTOBER 15

THINK ABOUT ...
Nature vs. Nurture

A study conducted by the University of Melbourne showed that 50 percent of your well-being is governed by genes. Of that other half, only 10 percent is connected to life circumstances like wealth, marital status, and attractiveness. That leaves 40 percent of happiness in our total control. Think about your day-to-day choices. Are you on the treadmill when you'd rather go for a swim? Cleaning your house when you'd rather pay someone to help? What simple changes can you make to be happier every day?

• • •

Reflect here: ..

..

..

..

..

..

..

..

October 16–17

~

*Some people could look at a mud puddle
and see an ocean with ships.*

~ Zora Neale Hurston,
Their Eyes Were Watching God

OCTOBER 18–19

*Write it on your heart that every day
is the best day in the year.*

~ RALPH WALDO EMERSON

OCTOBER 20–21

*There is so much in the world for us all
if we only have the eyes to see it.*

~ L. M. MONTGOMERY, *ANNE OF THE ISLAND*

Reflect here: ..

..

..

..

..

..

OCTOBER 22

⌒

PERSPECTIVE TIP
Game Changer

In a 2008 study published by the *Clinical Psychology Review*, scientists proved that gratitude reduces depression and increases life satisfaction. Take some time today to reflect on all the ways making gratitude a priority has enhanced your life this year. How has it affected your mood? Your energy level? How has it changed your perspective on life? Use these positive changes as a reminder to make gratitude part of your daily life for the long term.

• • •

Reflect here: ..

..

..

..

..

..

..

..

OCTOBER 23–24

The lowest ebb is the turn of the tide.

~ HENRY WADSWORTH LONGFELLOW

OCTOBER 25–26

*There is nothing either good or bad,
but thinking makes it so.*

~ WILLIAM SHAKESPEARE, *HAMLET*

OCTOBER 27–28

*There are always flowers for those
who want to see them.*

~ **HENRI MATISSE**

Reflect here: ..

..

..

..

..

..

..

October 29

TRY THIS
Attitude Adjustment

Make a game of finding gratitude in
every situation. Pay attention to situations
that annoy you or stress you out. Yard work
piling up? Grab a friend and invite her to help
so the two of you can catch up, get some fresh
air, and exercise together. Computers down
at work again? Use that time to organize
your desk or buy some flowers for the office.
Staying positive makes handling day-to-day tasks
and challenges more rewarding.

• • •

Reflect here: ..
..
..
..
..
..
..
..
..

OCTOBER 30–31

*Normal day, let me be aware
of the treasure you are.*

~ MARY JEAN IRION

NOVEMBER

Wisdom

NOVEMBER 1

WISDOM TIP
Getting to Know You

When faced with a tough decision,
look inward for answers. Sit quietly
and try to clear your mind; notice your
thoughts as they come and go, but try
not to follow them. Practice this meditation
for several days until the answer appears.
It may come to you while in the shower
or driving to work. Trust it.

• • •

Reflect here: ...
..
..
..
..
..
..
..
..
..

NOVEMBER 2–3

Life is made up of moments, small pieces
of glittering mica in a long stretch of gray cement.
It would be wonderful if they came to us
unsummoned, but particularly in lives as busy
as the ones most of us lead now, that won't happen.
We have to teach ourselves how to make room
for them, to love them, and to live, really live.

~ ANNA QUINDLEN

November 4–5

Adopt gratitude as the basic tenor of one's life—
gratitude for being alive, for being free, healthy,
and intelligent; gratitude for the senses and their
pleasures, the mind and its adventures,
the soul and its delights.

~ Johannes A. Gaertner

NOVEMBER 6–7

Enjoy the little things, for one day
you may look back and realize
they were the big things.

~ ROBERT BRAULT

Reflect here: ...

...

...

...

...

November 8

TRY THIS
Fitting It All In

If you fill a jar with rocks, then pebbles,
then sand, everything fits nicely. Put the sand
in first, however, and you'll run out of room
for the rocks. Try looking at your life this way.
Things that matter most—your health, family,
friends, and doing what you love—are your big
rocks. Get them in first. Let other, less
important things fill in the gaps. In the end,
you'll be grateful for spending time on
the things that truly mattered.

• • •

Reflect here: ..

..

..

..

..

..

..

November 9–10

*There is no such thing in anyone's life
as an unimportant day.*

~ Alexander Woollcott

November 11–12

Integrate what you believe in every single area of your life. Take your heart to work and ask the most and best of everybody else, too.

~ Meryl Streep

November 13–14

Time is the coin of your life.
It is the only coin you have,
and only you can determine
how it will be spent.

~ CARL SANDBURG

Reflect here: ..

..

..

..

..

..

..

..

NOVEMBER 15

─◦─

THINK ABOUT ...
Your Recipe for Living

If you were to write your own rule book,
what words of wisdom would you include?
Think about a few life lessons to impart—those
"aha" moments when you got everything right.
What valuable tips can you pass down to your
children? Next, reflect on ways that these rules
can guide you to greater peace and happiness
in your current life.

• • •

Reflect here: ...

...

...

...

...

...

...

...

November 16

*A gift is pure when it is given
from the heart to the right person
at the right time and at the right place,
and when we expect nothing in return.*

~ Vyasa

November 17–18

Things do not change; we change.

~ Henry David Thoreau

November 19

WISDOM TIP
Let It Go

Are you a perfectionist? Do you strive to do
your best *all the time?* Examine where giving
your all is most important to you—taking care
of a sick child or elderly parent, meeting work
deadlines, or getting regular exercise.
Then look for the times when being perfect
isn't as important: keeping the house spotless,
organizing a volunteer event, or planning
your family's Thanksgiving meal. Being okay
with "being okay" not only makes the journey
more fun—it alleviates potential disappointment
when things go awry.

• • •

Reflect here: ..

..

..

..

..

..

..

..

November 20–21

Instructions for living a life: Pay attention.
Be astonished. Tell about it.

~ MARY OLIVER

Reflect here: ..

..

..

..

..

..

NOVEMBER 22–23

The thing that is really hard, and really amazing,
is giving up on being perfect and beginning
the work of becoming yourself.

~ ANNA QUINDLEN

November 24–25

The purpose of life is to live it, to taste experience to the utmost, to reach out eagerly and without fear for newer and richer experience.

~ Eleanor Roosevelt

NOVEMBER 26

~

WISDOM TIP
Judge Me Not

Throughout the day, notice how often you
judge other people and situations. Reflect on
where these thoughts are coming from.
Though they may seem to be about other people,
your attitude can actually signal what's going
on internally. Decide to flip the switch
and appreciate the people and circumstances
in your life. Labeling things "good" or "bad"
keeps you stuck in absolutes; letting go of these
judgments opens the door to greater possibility.

• • •

Reflect here: ...

..

..

..

..

..

..

..

NOVEMBER 27–28

TRY THIS
Share the Wealth

Think of all the ways that focusing on gratitude
has changed your outlook. How has your life
changed since you began this journey? Choose
someone to share your new experiences with.
Imagine the ripple effect you can create
by inspiring just one person to embark
on his or her own gratitude journey.

• • •

Reflect here: ...

..

..

..

..

..

..

..

..

..

November 29–30

Praise the bridge that carried you over.

~ George Colman

DECEMBER

Harmony

DECEMBER 1

TRY THIS
Spread Joy

The holidays remind us to be thankful for family
and friends—but what about the other people
who help make our lives easier all year long?
Give a little gift to your mail carrier, cleaning
person, babysitter, even your librarian.
More importantly, include a note that says,
"Thanks for all your help this year."
Your words will mean more than any gift.

• • •

Reflect here: ...

..

..

..

..

..

..

..

December 2–3

After a storm comes a calm.

~ Matthew Henry

December 4–5

*When you find peace within yourself,
you become the kind of person who can live
at peace with others.*

~ PEACE PILGRIM

DECEMBER 6

~~~

## THINK ABOUT ...
### *Your Holiday Fun List*

As you enter the holiday season, think about
what brings you peace at this chaotic time
of year. Do you like to go to tree lightings
and outdoor festivals? Would you rather
do your shopping online to avoid the stressful
crowds? What holiday party can you say no to?
Take time to focus on what will make you happy
this month rather than getting caught up
in the whirlwind of everyone else's needs.

• • •

Reflect here: ...................................................................................

...................................................................................................

...................................................................................................

...................................................................................................

...................................................................................................

...................................................................................................

...................................................................................

...................................................................................

...................................................................

...................................................................

# DECEMBER 7

~

## HARMONY TIP
### *Peace, Love, and Stress*

When you encounter stress, your body releases
cortisol to help overcome it. Unfortunately,
in our busy culture this is activated so often
that our bodies aren't always able to return
to normal, which can lead to health problems.
But take heart: studies conducted by the
HeartMath Institute show that actively engaging
in thoughts of gratitude can lower cortisol by
23 percent, helping your body rebalance.
Focusing on gratitude this time of year is more
important than ever: Your health depends on it!

• • •

Reflect here: ....................................................................................

....................................................................................

....................................................................................

....................................................................................

....................................................................................

....................................................................................

....................................................................................

....................................................................................

# December 8–9

When you come right down to it, the secret
of having it all is loving it all.

~ Joyce Brothers

# December 10–11

*Woke up, it was a Chelsea morning,*
*and the first thing that I knew*
*There was milk and toast and honey*
*and a bowl of oranges, too*

~ Joni Mitchell

# DECEMBER 12

## HARMONY TIP
### *Have It All*

Today's media bombards us with messages
telling us we are not enough—not skinny, pretty,
or rich enough. We are taught that happiness
comes from owning big houses, fancy cars,
and designer clothes. But happiness actually
comes from enjoying what you already have,
not from wanting more. Take stock of what
brings you the most joy. You may be amazed
to find you already have enough of the things
that matter most—friendship, love, family,
laughter—to become your happiest self.

• • •

Reflect here: ..........................................................................................

..........................................................................................

..........................................................................................

..............................................................................

..............................................................................

...................................................................

...........................................................

.............................................

# December 13–14

*The first and fundamental law of nature is to seek out peace and follow it.*

~ Thomas Hobbes

Reflect here: ................................................................................

...........................................................................................................

...........................................................................................................

...........................................................................................................

...........................................................................................................

...........................................................................................................

...........................................................................................................

# December 15–16

Darkness cannot drive out darkness:
only light can do that.
Hate cannot drive out hate:
only love can do that.

~ Martin Luther King, Jr.

# DECEMBER 17–18

*Watch out for each other. Love everyone
and forgive everyone, including yourself.
Forgive your anger. Forgive your guilt.
Your shame. Your sadness. Embrace and
open up your love, your joy, your truth,
and most especially your heart.*

~ JIM HENSON

# DECEMBER 19

## HARMONY TIP
### *Nature Call*

Make a point of getting outside on a regular
basis—even on a cold winter day. Scientists at
Stanford University reported that being in nature
has restorative effects on the brain and provides
many psychological benefits including lowering
anxiety and improving memory. So bundle up and
get your body moving. Notice the sky, the trees,
the birds, and the wind, and your own harmony
with nature. Appreciate yourself for taking
the time to refresh your mind, body, and spirit.

• • •

Reflect here: ................................................................................

................................................................................................

................................................................................................

................................................................................................

................................................................................................

................................................................................

................................................................................

.........................................................................

................................................................

# DECEMBER 20

## THINK ABOUT …
### *Less Is More*

As the new year approaches, think about
how you can bring more simplicity to your life.
Can you clean out clutter from your workspace,
your purse, your car? Could your to-do list use
some pruning? Being able to relinquish
clutter—in the form of physical items, projects,
or even negative thinking—makes room
for peace and clarity, bringing greater joy
and appreciation for what matters most.

• • •

Reflect here: .................................................................................

...........................................................................................................

...........................................................................................................

...........................................................................................................

...........................................................................................................

...........................................................................................................

...........................................................................................................

...........................................................................................................

...........................................................................................................

...........................................................................................................

# DECEMBER 21–22

*I took a deep breath and listened to the old brag of my heart. I am, I am, I am.*

~ SYLVIA PLATH

# December 23–24

*It is good to listen, not to voices
but to the wind blowing, to the brook
running cool over polished stones,
to bees drowsy with the weight of pollen.*

~ Gladys Taber

# DECEMBER 25

⁓

## TRY THIS
### *Moving Forward*

Let this journal be your guide for the year
ahead. Take the time to review what
you've written and notice common themes.
For example, if you appreciated your
yoga class every week, explore ways to broaden
your practice. If you're grateful for your
grandchildren, find ways to spend more time
with them. Gratitude keeps you in touch
with what matters most and guides you
to lasting happiness. Reap every reward!

• • •

Reflect here: .................................................................................

..............................................................................................

..............................................................................................

..............................................................................................

..............................................................................................

...........................................................................

.............................................................

.......................................................

.............................................

# DECEMBER 26

~

## THINK ABOUT …
### *Setting Yourself Free*

No gratitude journey would be complete without
forgiveness. Think about an uncomfortable
situation you experienced this year. Notice how
thinking about it creates tension in your body.
Try to view the circumstances in a new light:
with empathy and compassion. Close your eyes
and imagine yourself letting go of any
leftover bitterness. Breathe easy.

• • •

Reflect here: ..........................................................................................
..........................................................................................
..........................................................................................
..........................................................................................
..........................................................................................
..........................................................................................
..........................................................................................
..........................................................................................
..........................................................................................

# December 27–28

⁓

*The way is not in the sky.*
*The way is in the heart.*

~ Buddha

# DECEMBER 29–30

*Out of clutter, find simplicity.*

~ ALBERT EINSTEIN

# December 31

TRY THIS
## *End on a Thank-You*

Use this prayer to close out your year in gratitude:

Thank you for all the lessons I've learned.

Thank you for all the opportunities
to love and be loved.

Thank you for all the meals I've eaten,
all the steps I've walked, all the beauty I've seen.

Thank you for _____
(name any people you are grateful for).

Thank you for this year in my life.

I am grateful.

• • •

Reflect here: ........................................................................................
................................................................................................................
................................................................................................................
................................................................................................................
........................................................................................
........................................................................
................................................................

# ACKNOWLEDGMENTS

I am so grateful to Allyson Dickman and the rest of the editorial team at National Geographic, especially Hilary Black, Katie Olsen, and Uliana Bazar, for the opportunity to contribute to this beautiful journey through gratitude. Thank you for helping to make this book a practical, inspiring guide for readers to embrace. Thank you to my husband, Daniel, for holding down the fort so I could meet every deadline and for supporting me every step of the way. Thank you to my son, Milo, for reminding me how joyful each and every moment in life can be. Thank you to Pamela Rich, Holistic Health Counselor, for introducing me to the power of gratitude. Thank you to Joshua Rosenthal, founder and director of the Institute for Integrative Nutrition, for inspiring me to focus my career on the one thing that has mattered most to me on my own journey—practicing gratitude.

# ABOUT THE AUTHOR

Lorraine Miller is an inspirational author, speaker, and coach who devotes her work to the practice of gratitude—what she believes is key to living one's healthiest, happiest life. She is a graduate of the Institute for Integrative Nutrition and has been studying natural health for over 15 years. Lorraine is the author of several books, including the best-selling journal *From Gratitude to Bliss: A Journey in Health and Happiness* and the award-winning children's book *Today I Am Grateful: Adventures in Gratitude.* Lorraine is also the creator of the *Gratitude to Bliss* mobile app. Learn more at GratitudeToBliss.com.

# ILLUSTRATIONS CREDITS

Cover, Henrik Larsson/Shutterstock; 2-3, pilipphoto/Getty Images; 7, Brian Hagiwara/Getty Images; 8, Mike Truchon/Shutterstock; 10-11, Alan Majchrowicz/Getty Images; 12, Marina Shanti/Shutterstock; 13, iStock.com/Noah Strycker; 14, Chamille White/Shutterstock; 15, Khomulo Anna/Shutterstock; 16, Pla2na/Shutterstock; 17, Kharlanov Evgeny/Shutterstock; 18, Thomas Zsebok/Shutterstock; 19, Madlen/Shutterstock; 20, Sergey Novikov/Shutterstock; 21, Kichigin/Shutterstock; 22, Creative Travel Projects/Shutterstock; 23, esp2k/Shutterstock; 24, pakornkrit/Getty Images; 25, Africa Studio/Shutterstock; 26, iStock.com/m-gucci; 27, kudrashka-a/Shutterstock; 28, Vilor/Shutterstock; 29, akiyoko/Shutterstock; 30, therightthumb/Getty Images; 31, Africa Studio/Shutterstock; 32-3, Kuttelvaserova Stuchelova/Shutterstock; 34, Artkot/Shutterstock; 35, EpicStockMedia/Shutterstock; 36, ArchonCodex/Getty Images; 37, Elena Veselova/Shutterstock; 38, Butterfly Hunter/Shutterstock; 39, Art Wolfe/Getty Images; 40, S.Borisov/Shutterstock; 41, pjhpix/Shutterstock; 42, Sergey Le/Shutterstock; 43, Ann Louise Hagevi/Shutterstock; 44, EcoPrint/Shutterstock; 45, Bozena Fulawka/Shutterstock; 46, Russell Shively/Shutterstock; 47, Montypeter/Shutterstock; 48, Marilyn Nieves/Getty Images; 49, KellyNelson/Shutterstock; 50, Diana Taliun/Shutterstock; 51, Kotenko Oleksandr/Shutterstock; 52-3, Christine/

# READ. BREATHE. LAUGH.

## with National Geographic Books

*Experience all of life's pleasures with Daily Calm, Daily Gratitude, Daily Joy, and Daily Peace. In these elegant books, 365 days of stunning photographs are paired with meaningful reflections that will uplift and nurture you every day of the year.*

## AVAILABLE WHEREVER BOOKS ARE SOLD

nationalgeographic.com/books